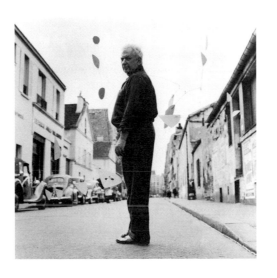

Front cover: *Untitled,* 1942
Back cover: Calder in his storefront studio,
New York City, winter 1937. Herbert Matter
Half-title page: Calder in Paris, 1954. Agnés Varda
Title page: *Black Beast* (detail), 1940
page 4: Calder in his Connecticut studio, 1944. Herbert Matter

For Gryphon Rue Rower-Upjohn
Thanks to my editors Julie Warnement and Debra Stasi

First published in the United States of America in 1998
by UNIVERSE PUBLISHING
A Division of Rizzoli International Publications, Inc.
300 Park Avenue South
New York, NY 10010

98 99 00 01 02/10 9 8 7 6 5 4 3 2 1

Library of Congress Catalog Card Number: 97-062509
ISBN: 0-7893-0134-2
Design and typography by Russell Hassell
Printed in Singapore

CALDER SCULPTURE

ALEXANDER S. C. ROWER

NATIONAL GALLERY OF ART, WASHINGTON

UNIVERSE

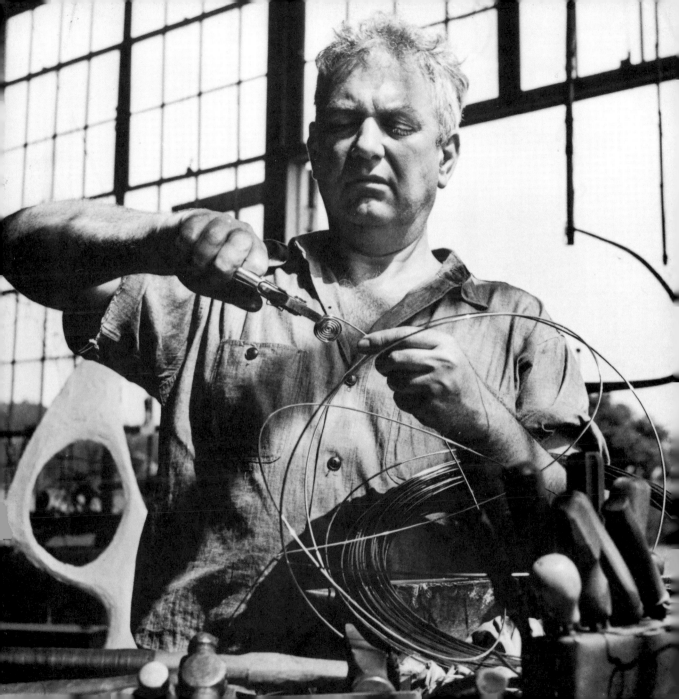

CALDERSCULPTURE

BY ALEXANDER S.C. ROWER

Simplicity of equipment and an adventurous spirit in attacking the unfamiliar or unknown are apt to result in a primitive and vigorous art. Somehow the primitive is usually much stronger than art in which technique and flourish abound.[1]
—ALEXANDER CALDER

Alexander Calder was an alchemist, transmuting simple industrial metals into exquisite constructions. He redefined sculpture by developing wire sculpting, which might be better described as drawing in space, and by formalizing kineticism with open sculptural compositions, "mobiles." With these objects he delineated the continuously unpredictable motion in sculpture.

Calder surrounded himself with his own production. His studios were jam-packed with works from all periods, and as he rediscovered "lost" pieces, they acted as stimuli for new ideas. For this reason, I don't believe a strictly linear progression is able to capture the complexities of Calder's life. Rather, it is my intention here to illustrate Calder's evolution as a sculptor by presenting some interrelationships within his work as it developed over the course of seven decades.

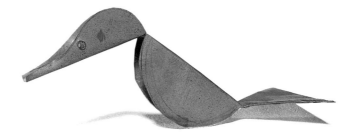

Duck, 1909

Alexander Calder was born 22 July 1898 in Lawton, Pennsylvania, to Nanette Lederer Calder, a painter, and Alexander Stirling Calder, a sculptor. He posed for both his parents throughout his childhood, and matured in the culture of the studio environment during the time of industrial mechanization. This nurtured his innate mechanical ability and, surrounded by an extended community of artists, his own artistic instinctual improvisation flourished at a young age. When he was eight years old, Calder's parents gave him his first tools and made certain he would always have a workshop to make toys, jewelry for his sister's dolls, games for his family, and works of art, which he gave back to them. At the age of eleven, he cut and folded a single piece of brass sheet into a duck that is remarkable in its

sophistication. Made not as a toy but as a sculpture, *Duck* was presented to his parents for Christmas.

He preconceived and penciled the design onto the flat, brass sheet before snipping and folding it—the sliver of back is all that remains of the original plane. Calder then demonstrated surprising economy, punching straight through both sides of the head in one stroke to create the eyes.

In 1919, Calder received a degree in mechanical engineering from Stevens Institute of Technology in Hoboken, New Jersey. This training in mechanics, while not critical to his development as an artist, would later be applied to his sculpting nonetheless. After college Calder held a series of positions involving drafting or engineering. Most important of these jobs was as a timekeeper and engineer at a logging camp in Washington State, where Calder became inspired by the mountain landscape and was compelled to paint. Finally, in 1923, he commited to painting and moved back to New York City to take up studies at the Art Students League.

For several years Calder eked out a living illustrating for newspapers and advertisers. In May 1925, he illustrated the Ringling Brothers and Barnum & Bailey Circus for the *National Police Gazette*. While on assignment he intently studied the circus, focusing on how the rigging was actuated and on the spatial relationships within the tent. Also in 1925, he began a

series of hundreds of brush drawings of animals, both exotic and ordinary, at the Bronx and Central Park Zoos in New York. (Some of these works appear in *Animal Sketching*, a how-to text written by Calder and published in May 1926.) Like his studies of the circus rigging, these brush drawings demonstrate Calder's keen interest in potential and kinetic energy. That fall, Calder moved into a tiny, one-room, living-working space on Fourteenth Street. There he constructed a bent-wire rooster attached to a wooden plank. With radiating lines drawn onto the base to indicate the time, this *Rooster Sundial*, his first wire sculpture, was positioned in Calder's window for practical reasons—he didn't own a watch.

In July, Calder decided to try living in Paris, which was then the center of the Modern art world. There, the twenty-eight-year-old artist began his kinetic experiments in earnest with the development of miniature, articulated circus performers. These figures, made variously of wire, wood, leather, cork, rubber, and bits of cloth, developed into acts that, over a few months, became a complete performance, the *Cirque Calder*. Calder was served well by his earlier fascination with circus mechanisms. His perceptive distillation of the natural circus was not a marionette show but early performance art; the ring activated by Calder was serious fun. In Europe, formal circuses were well respected, with specialized critics who reviewed them. One such critic, Legrand-Chabrier, favorably reviewed the *Cirque Calder* in 1927 and again in 1929.[2]

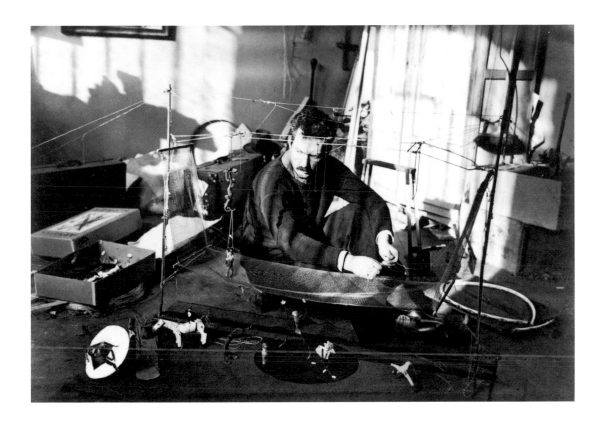

Calder with his *Cirque Calder*, 1927. André Kertesz

Overleaf
Left: *Lion Tamer.* Right: *Pegasus, Negress, and Dog* from *Cirque Calder*, 1926–1930. Herbert Matter

The intellectual nature of the performances was not lost on the Parisian art community, either. Calder developed close associations with the artists Jean Hélion, Joan Miró, Jean Arp, Fernand Léger, Piet Mondrian, and Marcel Duchamp, who came to experience his *Cirque Calder*; they in turn exposed him to modern notions of art while providing support for his own innovations.

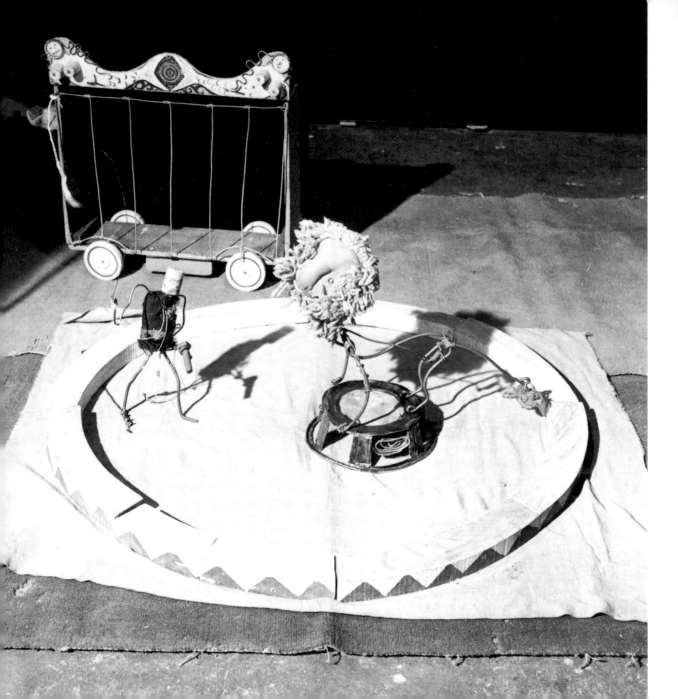

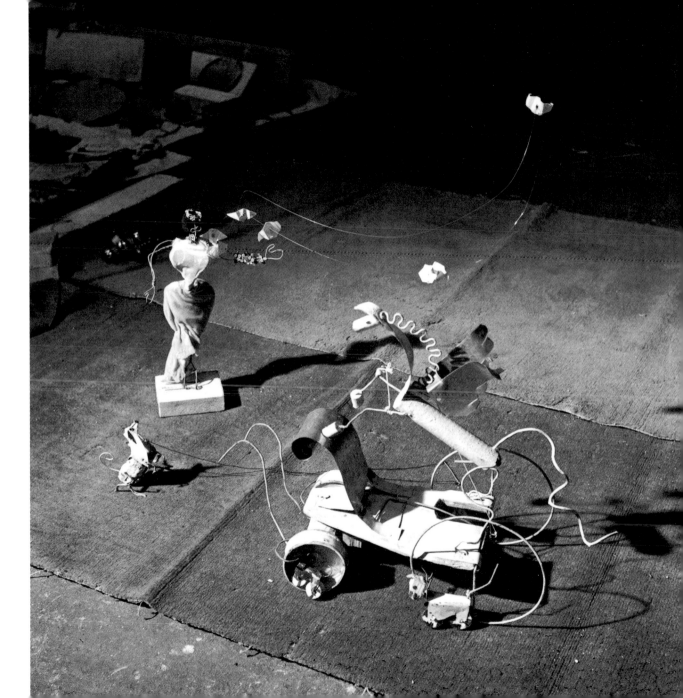

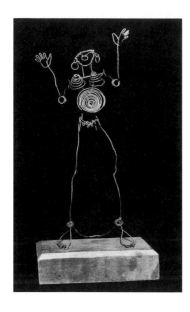 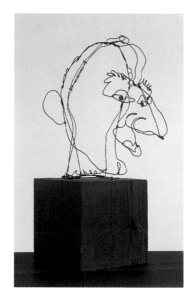

In the fall of 1926, a painter friend from the Art Students League visited Calder and suggested he try sculpting a figure completely from wire. Calder responded with a perceptive caricature of Josephine Baker, now lost. This figure of the cabaret sensation from America was made from a spool of brass wire and formalized with a heavy wood base. The same facility he had used in distilling the essence of the circus or in divining the nature of zoo animals, he now transferred to his new medium of wire. *Jimmy Durante*, made in 1928, is a classic example of Calder's wire portraiture—developed from his sketching and fused with his new wire sculpting techniques. Another wire portrait, *Kiki de Montparnasse*,

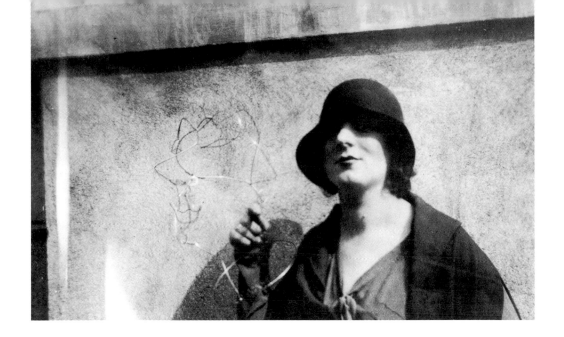

Kiki de Montparnasse with her wire portrait, 1929

was made in May 1929. Calder invited the renowned artist's model to sit for her portrait while Pathé Cinema filmed him at work in his studio at 7 rue Cels. In 1928 Calder made a few wire sculptures incorporating hand-turned, store-bought, wooden doorstops. In *Romulus and Remus*, the doorstops are used for the teats of the she-wolf and the sex of the two suckling infants. Another interpretation of a classical subject is *Hercules and the Lion*, made in 1929. While *Romulus and Remus* is static, *Hercules and the Lion* was designed to rotate, like the wire portraits, and to cast a shadow on the wall. Hercules' powerful shoulders support the entire configuration while he battles with the lion.

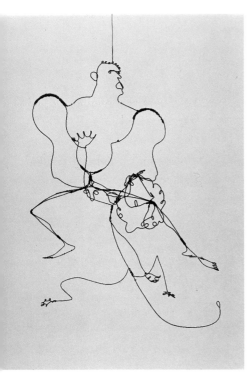

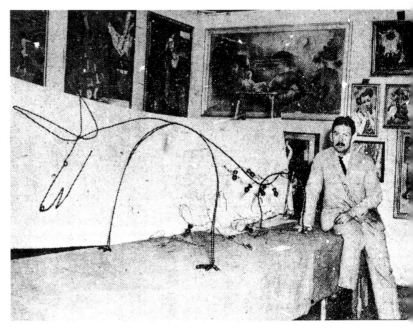

Hercules and Lion, 1929 Calder with *Romulus and Remus*, 1928

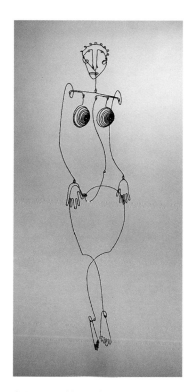

Aztec Josephine Baker, c. 1929

Calder fully devised articulation and motion in his sculpture, adding the dimension of time in 1929. Though he had previously created works incorporating movement, such as the jointed performers in his *Cirque Calder* and his hanging wire sculptures, he now formalized this dimension with works like the final hanging version of the cabaret performer, *Aztec Josephine Baker*. In this ambitious figure, motion is so successfully expressed in her fully articulated body and fluidly jointed extremities that my grandfather was known to dance with her. In December 1929, Calder was inspired by an exhibition of mechanical birds to make an even more complex fish tank than the wire *Aquarium* he was currently exhibiting in a nearby gallery.[3] *Goldfish Bowl*, made as a Christmas gift for his mother, employs a crank-driven mechanism that persuades the two fish to writhe. This adeptly made object was the precursor to the articulated and mechanized objects that developed over the next two years, especially the crankable *Two Spheres Within a Sphere*. Here, Calder supplanted the fish with two nonobjective spheres.

As Calder moved toward abstraction in 1929–1930, his figurative sculpture became more gestural with the dynamic force of the figure becoming the primary focus and specific detail becoming less important. In *Circus Scene* and *Le cavalier*, the wire drawing emphasizes these dynamic forces with the use of thick and thin wire. *Le cavalier* represents the final phase of Calder's figura-

15

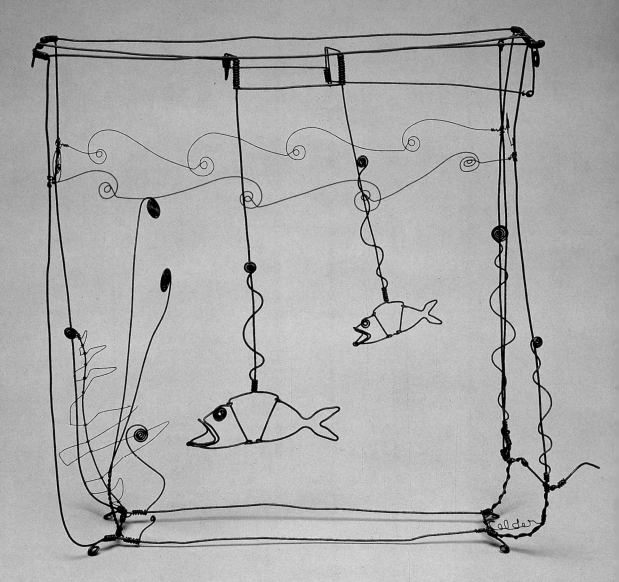

Goldfish Bowl, 1929

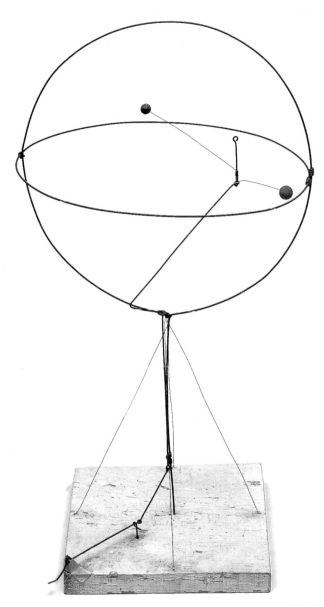

Two Spheres within a Sphere, 1931

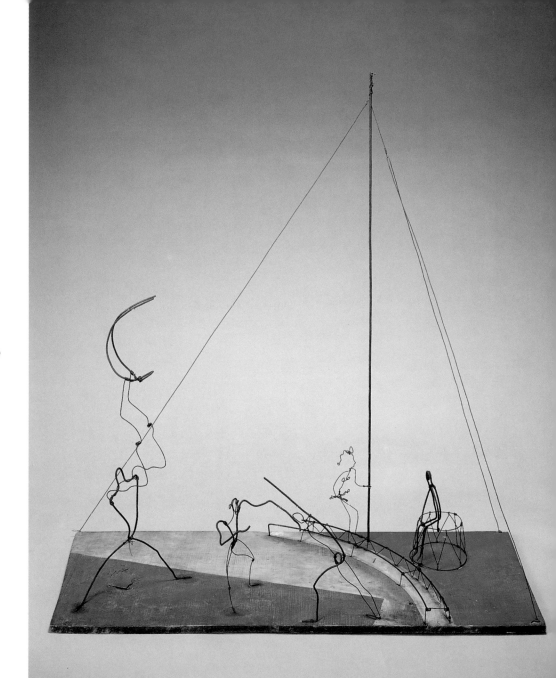

Circus Scene, 1929

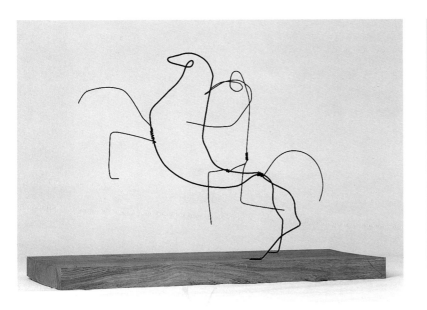

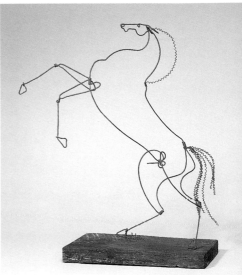

Le cavalier, c. 1930

Rearing Stallion, c. 1928

tive works: here gesture is all important, with no features expressed, yet the mastery of this horse compares well with that of *Rearing Stallion*, circa 1928.

Calder visited Piet Mondrian at his studio in October 1930. It was not Mondrian's geometrically abstract paintings, but the studio environment that deeply impressed him. The whole place was a work in progress, with one wall of colored paper rectangles that could be easily repositioned for compositional experiments. When Calder suggested oscillating the colored rectangles,

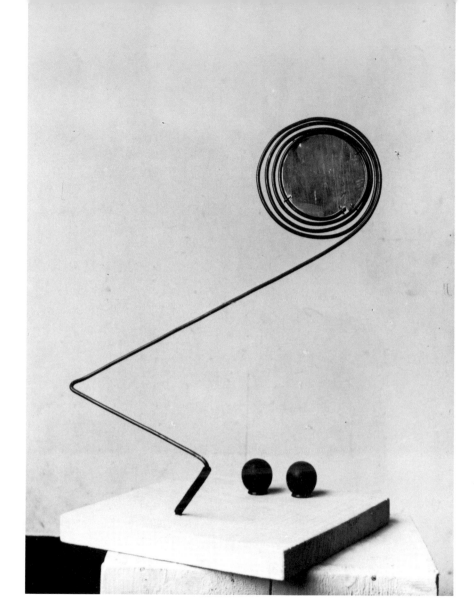

Féminité, 1930

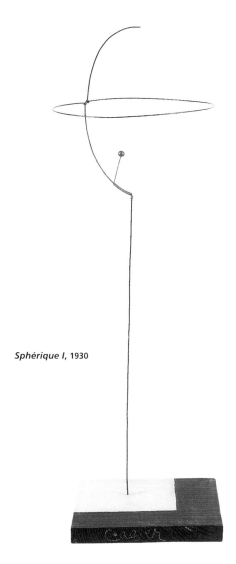

Sphérique I, 1930

Mondrian replied, "No, it is not necessary, my painting is already very fast."[4] Calder later recounted that this studio visit "shocked" him toward complete abstraction. My grandfather's interest in Mondrian's studio environment reminds me of his earlier interest in the spatial relationships of the circus tent, with its complex rigging and systems in place, all ready to be put into action.

After that visit Calder made about twenty oil paintings in an abstract, nonobjective manner. Actually, he had already turned in that direction with his 1929 *Circus Scene,* whose geometrically painted baseboard was made earlier yet is clearly related. After two or three weeks he began to construct abstractions, using the same steel wire and wood he had employed in his figurative works. *Féminité*, later titled *Kiki's Nose*, was probably Calder's first wire sculpture in the abstract. The face is an interpretation of Kiki's wire portrait head of the previous year. It consists of a singular wire, the nose, that zigzags up from a wooden base painted white and continues to a spiral encompassing a round element of sheet metal, the eye. As with *Romulus and Remus*, Calder used store-bought door parts, attaching to the base two doorknobs painted black to suggest the nostrils. Possibly as significant as the development of the abstract object itself was Calder's use of the wooden planks he kept stacked in his studio for use as bleachers during performances of his circus. These he cut up to utilize as bases in his latest sculptures in a remarkable

act of literally displacing his audience: a symbolic purging of his *Cirque Calder*. And as in *Circus Scene*, the painted plank base of one of these new works, *Sphérique I*, evokes some of the more geometrical abstractions Calder had painted on canvas a few weeks earlier.

In December 1930 Calder returned to the United States to marry my grandmother, Louisa James. The couple settled in Paris in February 1931 and Calder joined the newly formed *Abstraction-Création* group. This collective was very supportive of his new work, and through his association with it he was able to mount his first exhibition of abstractions at Galerie Percier in April.[5] Included in that exhibition was *Croisière*, in which Calder used thick and thin wires—as in *Le cavalier*—to describe the dynamic forces of the object. At the time of the exhibition, Louisa bought a small dog, a French briard mix they named Feathers because of its wispy hair. Shortly after, Calder expressed the brassiness of this dog in an abstract sculpture, *Feathers*. Whereas his 1925–1926 animal sketches could only imply motion, this work is an abstraction in actual motion: its energy is expressed kinetically.

My favorite work from this period is *Object with Red Ball*. The two spheres—one constructed from two intersecting discs, the other a wooden ball—are placed along a horizontal rod with no fixed positions. The main support, set on a pin, pivots at the base. These variable adjustments propose an open composition,

Croisière, 1931

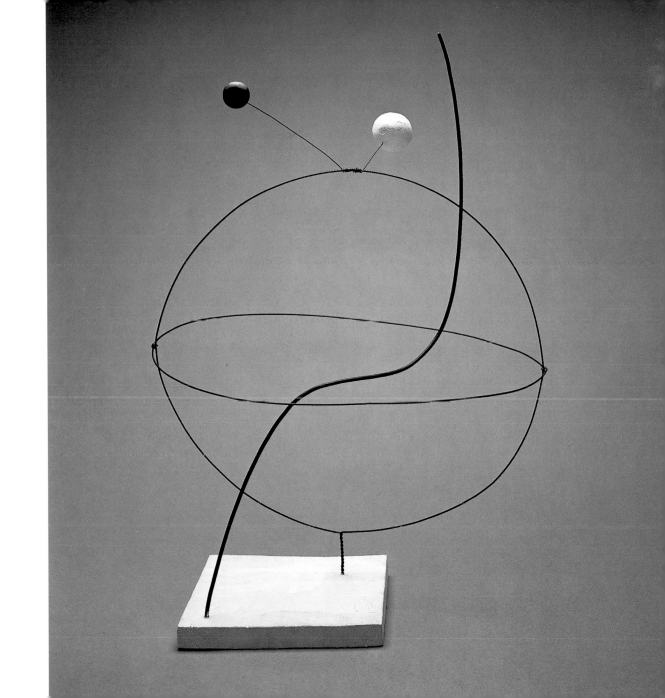

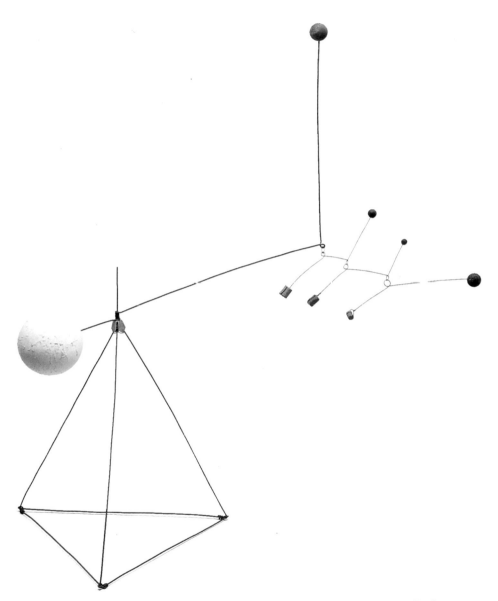

Feathers, 1931

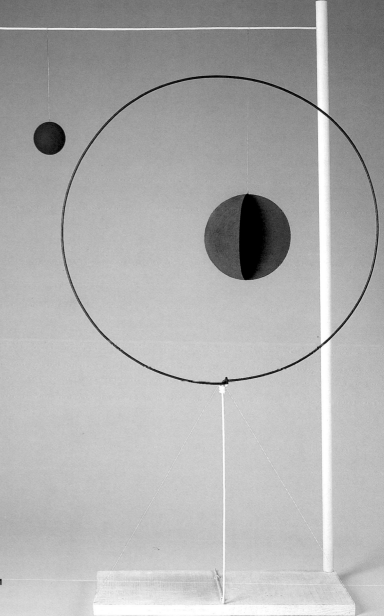

Object with Red Ball, 1931

allowing the viewer to alter the interrelationships and determine the ultimate composition. Calder explained ". . . I introduced flexibility, so that the relationships would be more general. From that I went to the use of motion for its contrapuntal value, as in good choreography."[6] Calder's notion of sending painting into motion sent his own compositions into a netherworld between painting and sculpture: his constructions required a new category, a new terminology. Calder considered them "plastic forms" in "several motions of different types, speeds and amplitudes composing to make a resultant whole." Just as the artist "can compose colors, or forms," so, too, can he "compose motions."[7] During one of many visits to Calder's studio, Marcel Duchamp was impressed by an early motorized composition, *Untitled*, 1931, and at Calder's prompting, ventured "mobile" to describe such sculpture. Calder was very pleased by the suggestion, as it corresponded with his own penchant for double entendre: in French *mobile* refers to both motion and motive. Duchamp, arranging for an exhibition at Galerie Vignon in 1932, proposed the title *Calder: ses mobiles* and designed the announcement card.[8] Upon seeing the exhibition, Jean Arp facetiously came forth with "stabiles" for Calder's first abstract sculptures shown the previous year at Galerie Percier.[9]

A year later, Galerie Pierre exhibited *Arp, Calder, Miró, Pevsner, Hélion, and Seligmann*. Calder included *Cône d'ébène*, a large mobile with three lumbering ebony objects. He employed

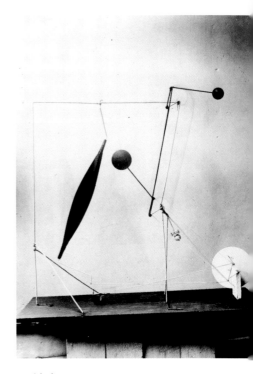

Untitled, 1931

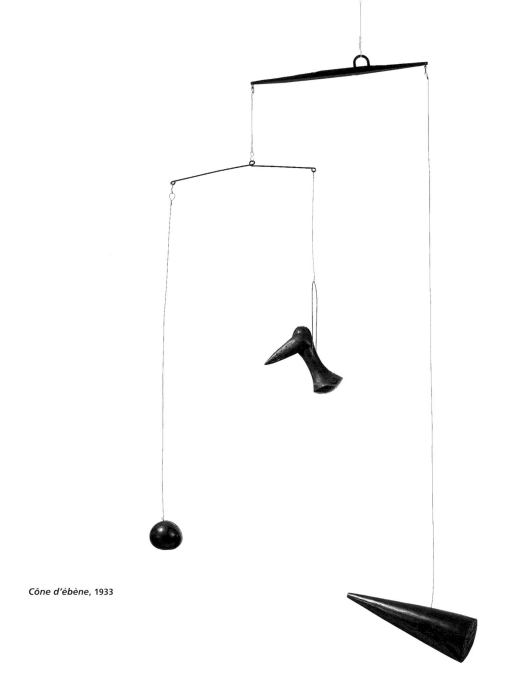

Cône d'ébène, 1933

primitive carving here as he had in earlier, figurative works and would again in a later series of objects, some stationary, some in motion, from 1935–1936. One, *Gibraltar*, 1936, incorporates the wooden spheres of the very first abstractions, as well as the rough carving seen in *Cône d'ébène*. James Johnson Sweeney, an American art critic, met Calder at the 1933 Galerie Pierre exhibition and the following year agreed to write a catalogue introduction for Calder's first exhibition with the Pierre Matisse Gallery in New York.[10] Calder later offered him a sculpture from the show as a gift. Sweeney, always a man of principle, insisted on giving Calder a small payment and chose *Object with Red Discs*, 1932, a large-scale, confident, standing mobile that had also been exhibited at Galerie Pierre. Its group of sheet metal elements is the direct ancestor of the hanging mobiles initiated soon after.

In June 1933 the Calders returned to America after living two years in Paris. Louisa wanted to have a family and Europe was beginning to feel what would become the Nazi decimation. They decided to winter in New York City and live the rest of the year in the country, so they bought a small farm in Roxbury, Connecticut, with some borrowed money as a down payment. The house, a center-hall colonial, needed everything from plumbing and electricity, to new windows and paint. They spent the remainder of that year renovating the house and Calder produced little sculpture. He did make simple kitchen cabinetry

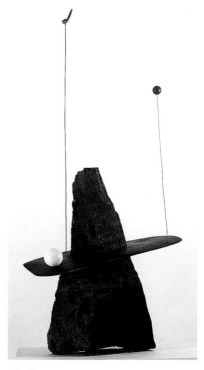

Gibraltar, 1936

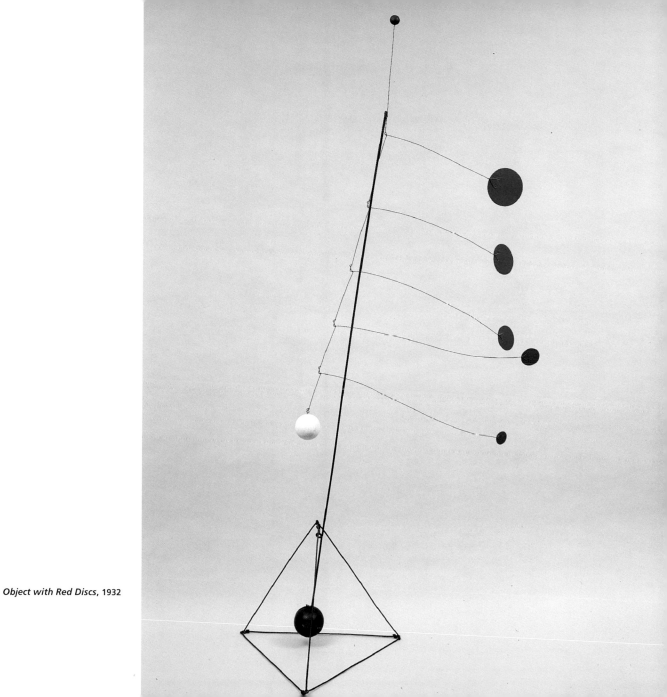

Object with Red Discs, 1932

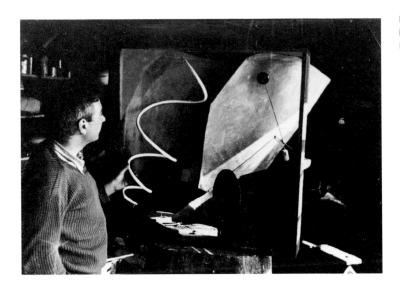

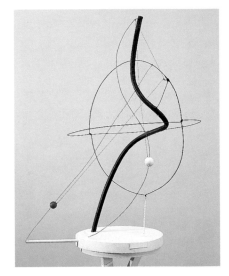

from the wide boards of the crates that had transported their possessions. Louisa later painted her own bold, yellow, border design on the deep red floors of the halls and stairs. Calder converted the adjoining icehouse into a modest dirt-floored studio where he created some of his most dynamic work.

In 1934 Calder drew upon earlier works, creating *A Universe*, a hybrid of his first volumetric abstractions of 1930–1931 and the motorized objects of 1931–1932. The complex mechanism that manipulates the ballet of the rising and falling balls is separate, "off stage," out of view. In *Black Frame*, Calder took the next step, enclosing the integral mechanism in a box and providing a backdrop, or stage, against which his objects moved. Here the

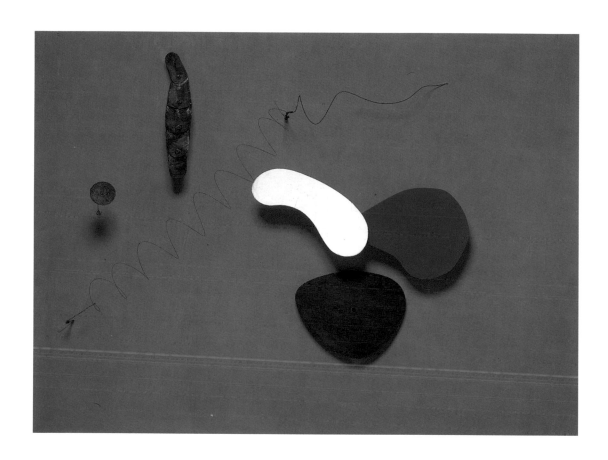

The Orange Panel, 1936

motions are more complex, with a rotating helix, a red sphere in a skewed orbit, and a disc alternately flashing yellow and red, all against a sober field of gray sheet metal. Calder wrote ". . . the idea of detached bodies floating in space, of different sizes and densities, perhaps of different colors and temperatures, and surrounded and interlarded with wisps of gaseous condition, and some at rest, while others move in peculiar manners, seems to me the ideal source of form."[11] This "ideal source of form" had been brewing for some time; once as a merchant marine off Guatemala in June 1922, Calder had awakened on deck to an ecstatic vision that became a source of inspiration: a brilliant sun and a full moon in buoyant symmetry on opposite horizons.

The Orange Panel, 1936, is Calder's last important motor-ized object: all of its variegated motions are achieved through one motor and a complex drive. These motorized sculptures, as they cycled through their performances, had a predictability which ultimately disappointed Calder, and he struggled to devel-op compositions that were less calculable.

In 1936, with *Red Panel* and the following two works, Calder finally achieved unpredictable compositions in motion with certain simplicity and beauty. His *Snake and the Cross* (like its precursor *Black Frame*) is a dynamic exercise in nonobjective sculpture, with an amazing cantilevered frame held by two upper pins; only two rods project the frame from the wall. And in his *White Panel*,

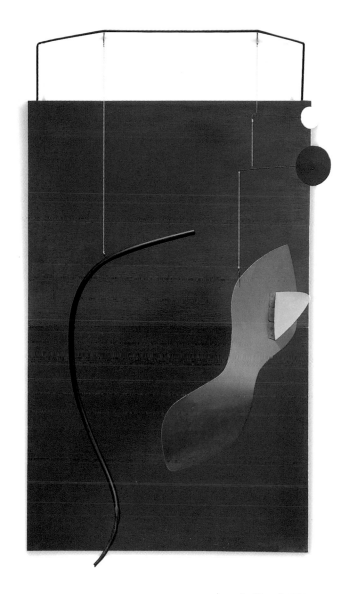

Red Panel, 1936

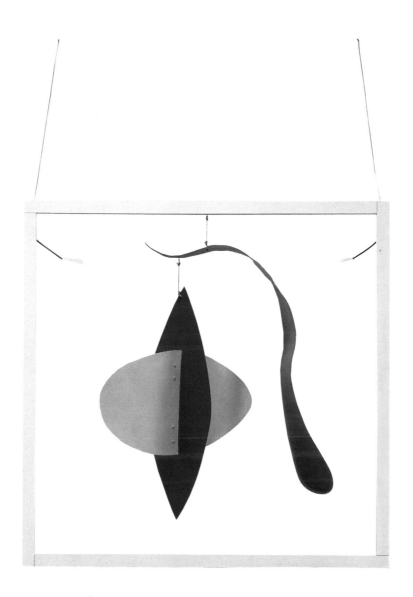

Snake and the Cross, 1936

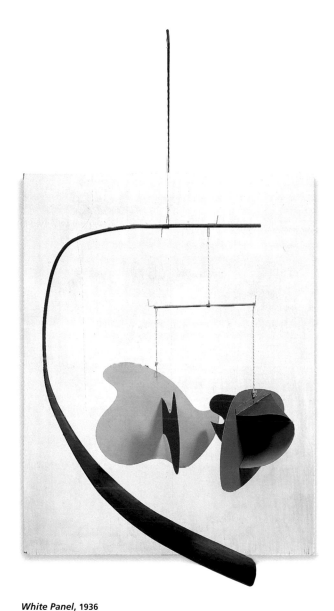

White Panel, 1936

Calder devised cranks for winding up the strings, which when released set the forms in motion—forms that are also wind driven. The two central elements collide, making unpredictable sounds. Calder's interest in this type of open-form "music" dates back to 1931, when the composer Edgard Varèse began making frequent visits to the sculptor's studio, as he felt Calder's constructions resonated with his own experiments. "Varèse," Louisa recounted to her mother-in-law, "likes to watch him work."[12]

With these last three works, Calder achieved the paintings in motion he had suggested to Mondrian in 1930. They are the apex: true paintings in motion, successfully incorporating the unpredictable qualities that escaped the motorized works. Defined by the panels and the frame, they are bound to the wall, their "frame" of reference, and yet they are free.

In Roxbury, during the summer of 1934, Calder made his first outdoor works: *Untitled* was designed to be "planted" by pushing the rod ends firmly into the soil. While light and graceful, its thin aluminum could not survive the battering of the elements; the piece had to be brought inside whenever the climate shifted. His next work, *Steel Fish*, because it was engineered out of steel, could endure the weather.

Whale, 1937, was the first sculpture designed and enlarged from a maquette. This development might be compared to the methods that his sculptor father and grandfather had employed

Untitled, 1934

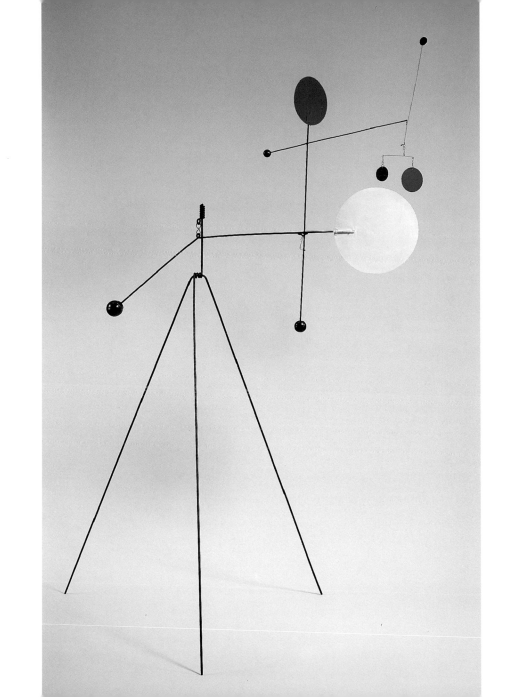

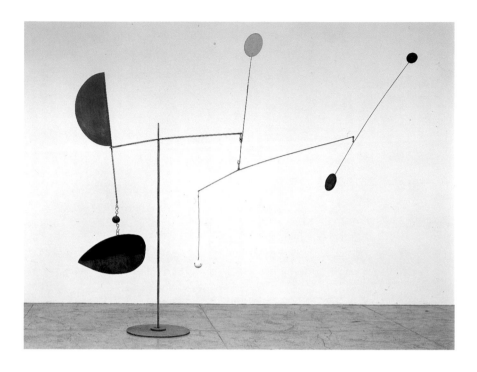

Steel Fish, 1934

themselves when enlarging a commission from a plaster model to
the full-size bronze. Calder fabricated *Whale* in New York during
the winter of 1936–1937. He constructed this stabile from sheet
steel that he cut, formed, and assembled with bolts, as if it were
a machine. After exhibiting *Whale* and other works with Pierre
Matisse,[13] Calder, with Louisa and their two-year-old, Sandra,
returned to Paris for the first time since 1933. There Miró intro-
duced him to Josep Lluis Sert and Luis Lacasa, the architects of
the Spanish Pavilion at the World's Fair, which opened later that

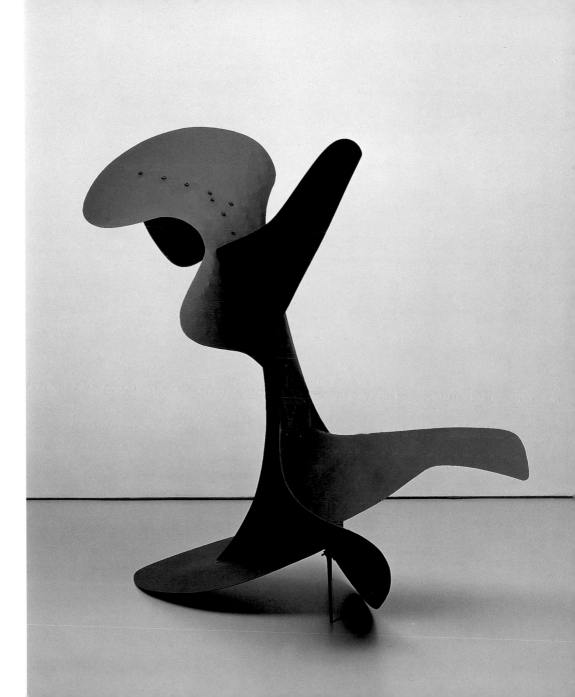

Whale, 1937

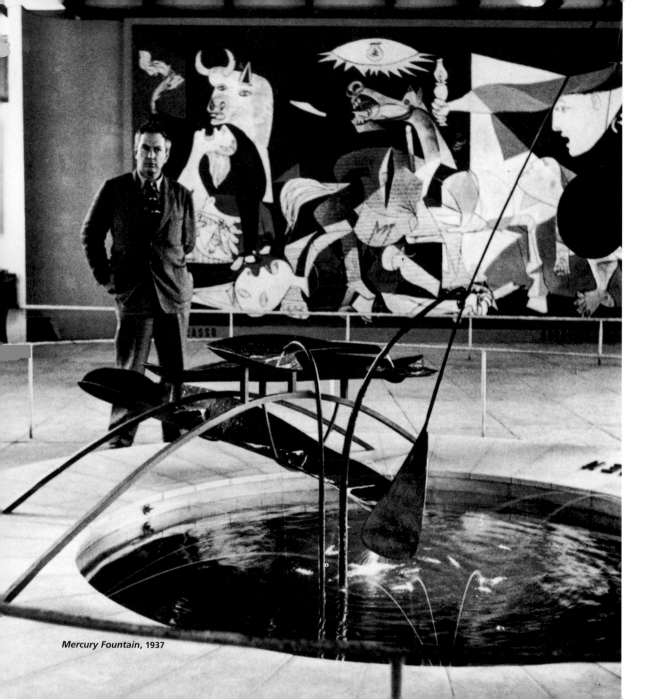

Mercury Fountain, 1937

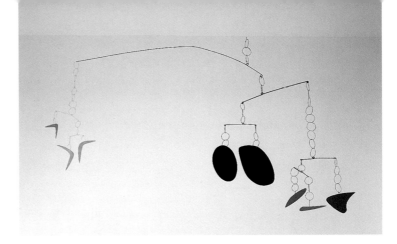

Untitled, 1941

summer.[14] In mid-May, Sert commissioned Calder to make *Mercury Fountain* for the pavilion, which also featured large paintings by Miró and Picasso. In the fountain, mercury travels down a series of sheet metal ellipses, finally splattering against a paddle, which vibrates with the force of the impacting liquid metal and defiantly waves a flag of wire letters spelling out ALMADEN. The mercury, from a mine in Almadén, Spain, symbolized Republican resistance to the fascism of Franco.[15]

In 1938 Calder built a new studio in Roxbury on the foundation of a burned-out barn and immediately began filling it with his works. The wind, blowing through the industrial sash windows, would stir the mobiles and make them collide, creating an unforgettable cacophony. *Untitled*, 1941, is a mobile with colliding elements intended to gong and clang, reminiscent of the sounding objects in *White Panel*.

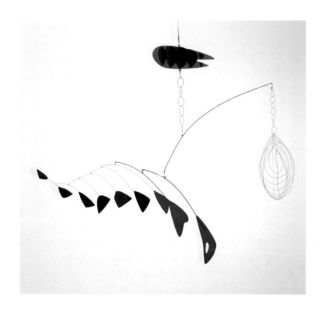

Lobster Trap and Fish Tail, 1939

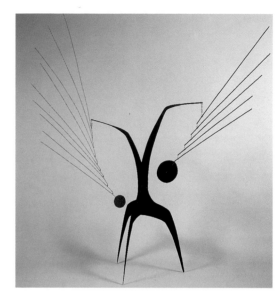

Un effet du japonais, 1940

In 1939 Calder made *Lobster Trap and Fish Tail*, a large mobile commissioned for the principal stairwell of the Museum of Modern Art's new building on Fifty-third Street. In 1940, he constructed *Un effet du japonais*, a gorgeous object with two fanning mobiles, and *The Spider*, the final piece in a series of standing mobiles incorporating this "fanning" composition. *The Spider* was exhibited in *First Papers of Surrealism,* a New York show curated by André Breton with the collaboration of Marcel Duchamp.[16] Initially, at Duchamp's invitation, Calder was to hang works from Duchamp's *Mile of*

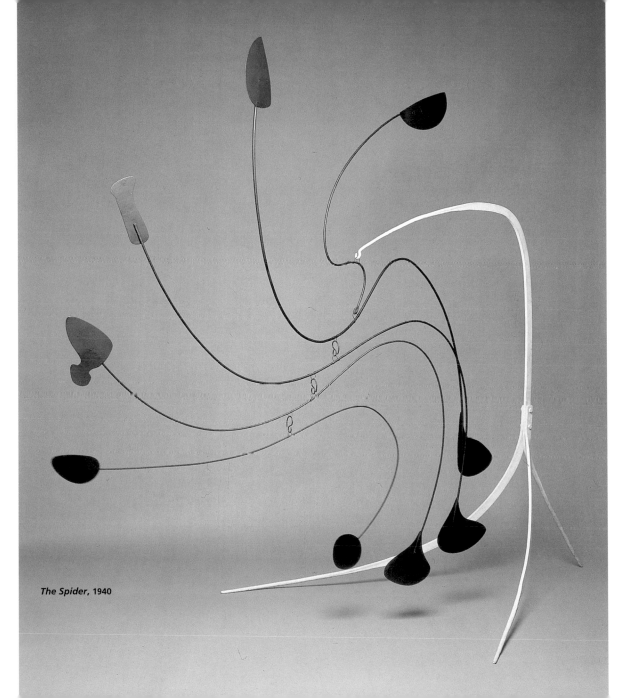

The Spider, 1940

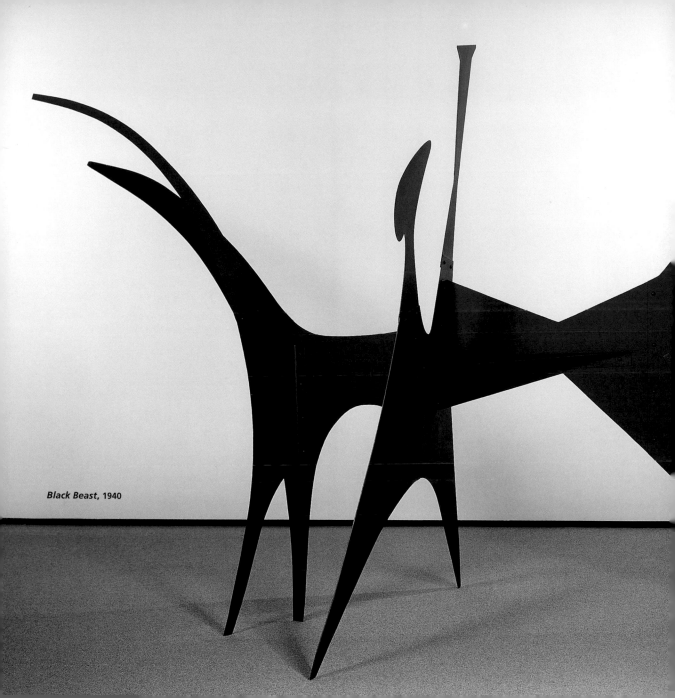

Black Beast, 1940

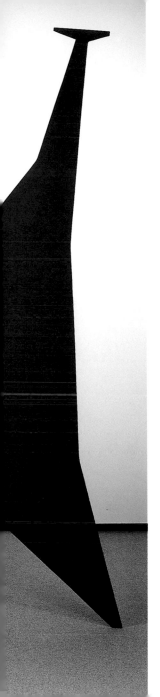

String, a complex web that enveloped the entire exhibition space and forced spectators under and around the string in order to see all the works displayed. Calder had begun hanging paper objects (in a play on the title of the show) but Breton vetoed the idea, so *The Spider* was shown instead.

Calder's largest sculpture to date, *Black Beast*, 1940, represents the dynamic fruition of his previous experiments and was his most ambitious project, foreshadowing the monumental public sculptures to come. It was enlarged from a maquette, but the fabrication of the full-size object was executed by technicians working under Calder's supervision, not by his own hands. As with *Whale*, he had conceived of monumental works and was ready for commissions to produce large sculptures in any scale, but it wasn't until almost two decades later that the world was ready to accept huge public art to complement the architecture of the International Style.

The entrance of the United States into World War II in 1941 signaled a shift in Calder's materials. He was by no means uncomfortable with the scarcity of his accustomed supplies, as it corresponded with his principle of economy, and simply used what was available. "Sculptors of all places and climates have used what came ready to hand. They did not search for exotic or precious materials. It was their knowledge and invention which gave value to the result of their labors."[17] He utilized broken shards of glass

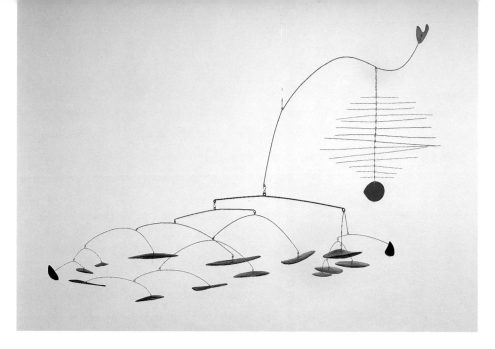

and other found objects extensively in his sculptures, and he returned to wood carving, shaping abstract elements.

Constructed in 1941, *Floating Wood Objects and Wire Spines* was one of the first objects Calder made with the intention of minimizing his use of strategic materials. The industrial aluminum sheet he preferred was needed to construct aircrafts, among other weaponry. *Floating Wood Objects and Wire Spines* was originally conceived and exhibited as a standing mobile with a base made of steel rod, but the base was soon discarded and Calder allowed the piece to be hung from the ceiling. This seminal object has delicate, horizontal spines, which reappeared in

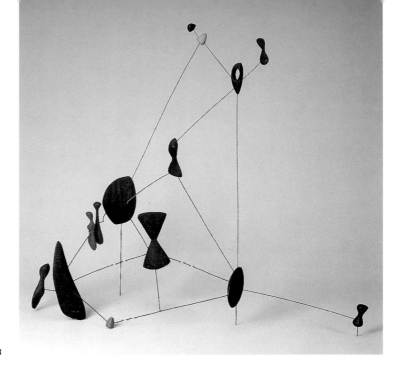

Constellation, 1943

important works a year later, and the carved-wood elements—
the most exciting feature of the work—developed over the next
two years into a new, open form of sculpture. These new wood-
and-steel-wire constructions were shown in 1943 for his last exhi-
bition with Pierre Matisse.[18] Calder said they had "a suggestion
of some kind of nuclear gases,"[19] but it was Duchamp, together
with Sweeney, who devised the word "constellations" for these
objects.[20] While the majority hang on the wall, his penultimate
constellation, made in 1943, is a standing version, with blue and
red wood forms that spin around their supporting wire.

In September, the Museum of Modern Art in New York opened Calder's second retrospective exhibition,[21] curated by Sweeney with some collaboration from Duchamp. It was such a success that the museum decided to extend the show for over a month. However, *Red Petals,* which was installed prominently in the museum's main entryway, was owned by the Arts Club of Chicago, who would not allow it to remain beyond the original closing date. The Arts Club had just recently received this commissioned work from the artist, and had only reluctantly agreed to the loan in the first place. Calder, ever responsive to a challenge, quickly made *The Big Ear*, enlarging it from a maquette that he then gave to Sweeney. This sculpture, a descendant of *Black Beast*, is less restrained in character and well deserves to be called a stabile, as it has both a solid relationship to gravity and a perplexing buoyancy.

The war had a lasting effect on Calder's work. Conserving his materials, he made a series of small-scale works, many from scraps trimmed in the process of making other objects. In the summer of 1945, Duchamp, admiring these recent works, suggested mailing them to the dealer Louis Carré in Paris for an exhibition.[22] Duchamp cabled Carré with the proposition. Calder, inspired by the challenge of maximizing the scale of the works exhibited, began making larger works that could be disassembled to fit into the biggest package allowable by the United States Postal Service.[23] Works thus made to be disassembled and pack-

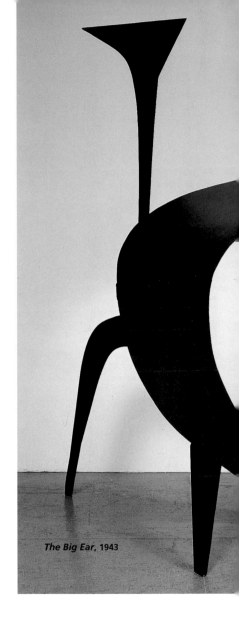

The Big Ear, 1943

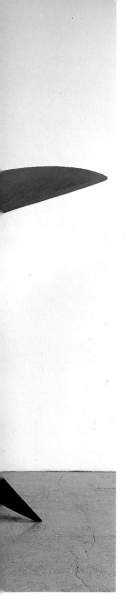

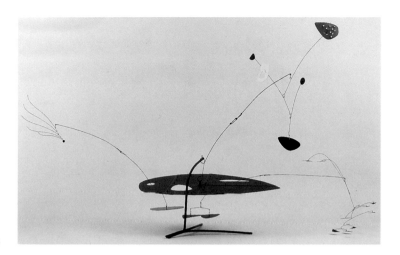

Baby Flat Top, 1946

aged can be identified by the ingenious hinge in the wire arma-
tures and by other construction details developed to aid in their
shipping. In *Baby Flat Top*, 1946, the large, pierced, horizontal
element was bolted in sections, rendering the sculpture
completely demountable to a few pounds of easily mailed metal.

The 1940s were also marked by graceful and sophisticated
sculptures with pierced elements. In *Untitled*, 1942, the vertical
element, an industrial scrap punched with a pattern of small holes,
acts as counterpoint to the rest of the work's delicate and weighty
elements, their negative space vibrating energetically. Calder made
1 Red, 4 Black plus X White in 1947, a mobile whose grand simplic-
ity is formed by a complex of interchanging relationships. Its one
vertical element, pierced and painted red, can rotate fully on its

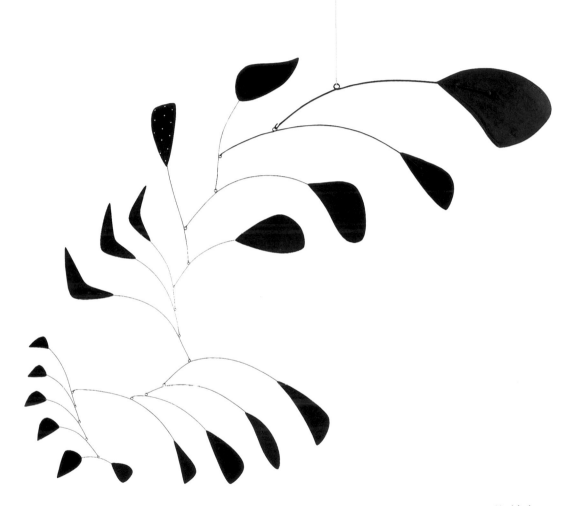

Untitled, 1942

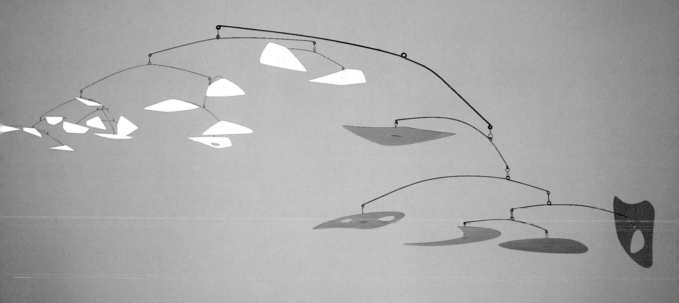

1 Red, 4 Black plus X White, 1947

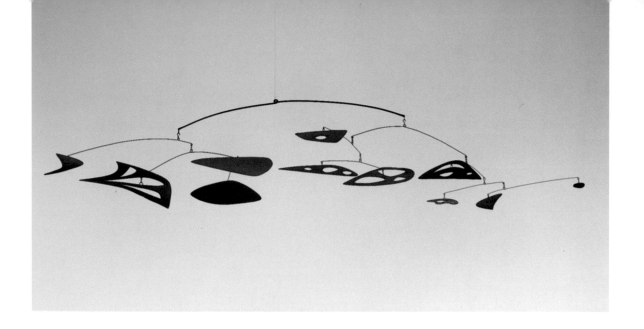

wire axis while the rest of the element groups contract and expand in motion. *The Lace on the Edge of Your Panties*, made that same year, carries the skeletal motif of the period to fruition with its seemingly moth-eaten, cutout elements, and it also vibrates powerfully with negative space. Of the series of standing mobiles with surreal pierced discs made in 1947, the most notable are *Bougainvillier*, the largest and most mature of the series, and *Little Parasite*, whose riveted base with an arcing leg and striking gray-and-black scheme is exceptional in its refinement.

After the War, Calder made about a dozen hanging fish, whose bodies were constructed from steel rod interlaced with

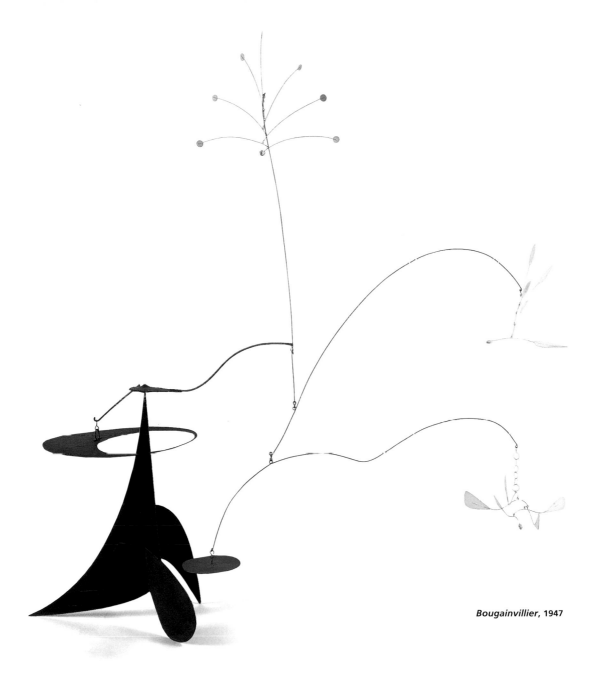

Bougainvillier, 1947

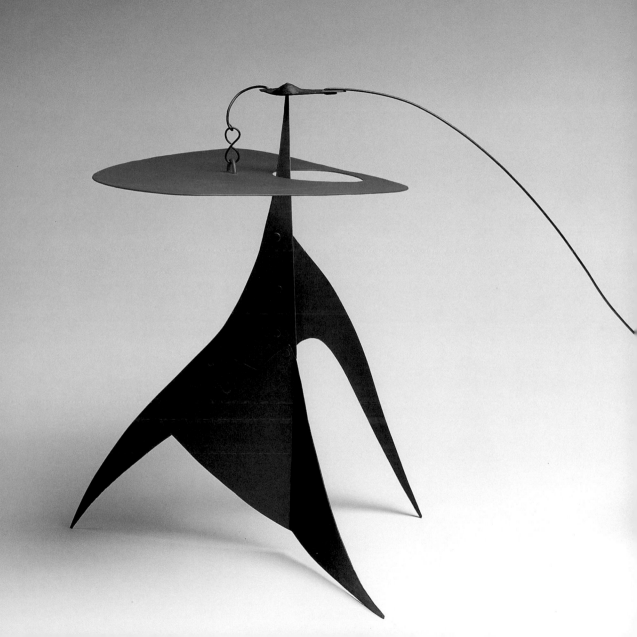

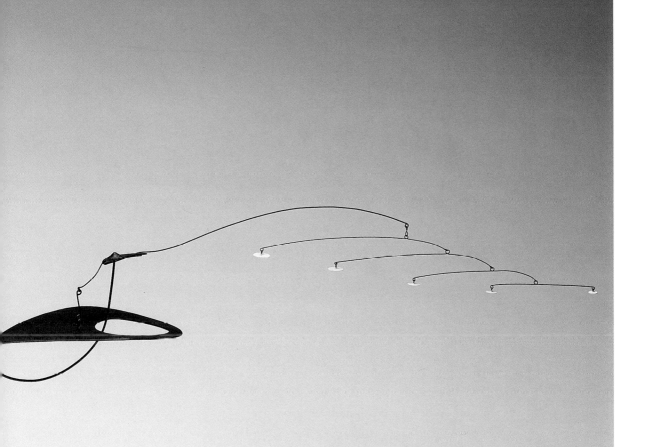

Little Parasite, **1947**

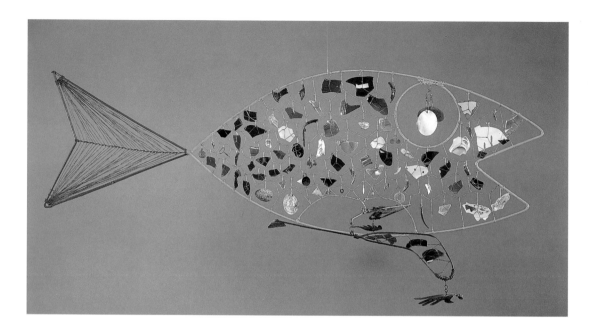

wires suggesting scales. In each of these voids Calder suspended glass fragments and other found bits. In *Finny Fish*, 1948, the greatest of these works, these bits include a sardine-can key and the flattened bowl of an absinthe spoon. Calder traded this object for *The Sculptor*, 1942, a painting by his friend Rufino Tamayo.

Calder's final foray into wire constructions was a series of projecting wall-derricks called towers. These works, reminiscent of the constellations, often incorporated small objects that Calder had made in earlier periods and kept around his Roxbury studio. In *Tower with Painting*, 1951, the wooden elements date back to

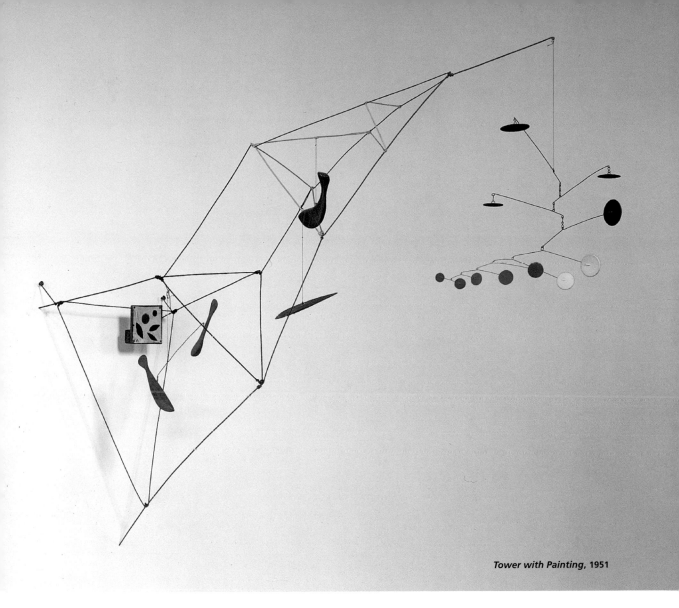

Tower with Painting, 1951

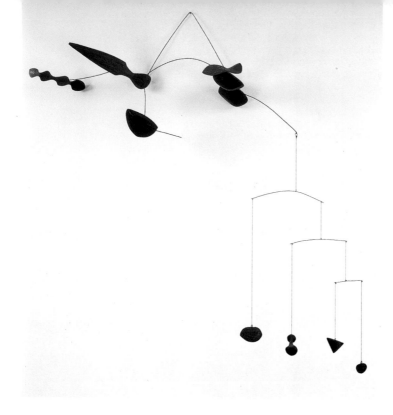

Constellation with Mobile, 1943

the constellations of 1943 and the miniature painting is from about 1945. One tower even has a beautifully constructed object from the mid-1930s.

In 1949, *International Mobile,* Calder's largest to date, was made for the 3rd International Exhibition of Sculpture in Philadelphia.[24] Calder planned and constructed this impressive flurry of white elements to fill the main stairwell of the Philadelphia Museum of Art. And in 1952 Calder represented the United States

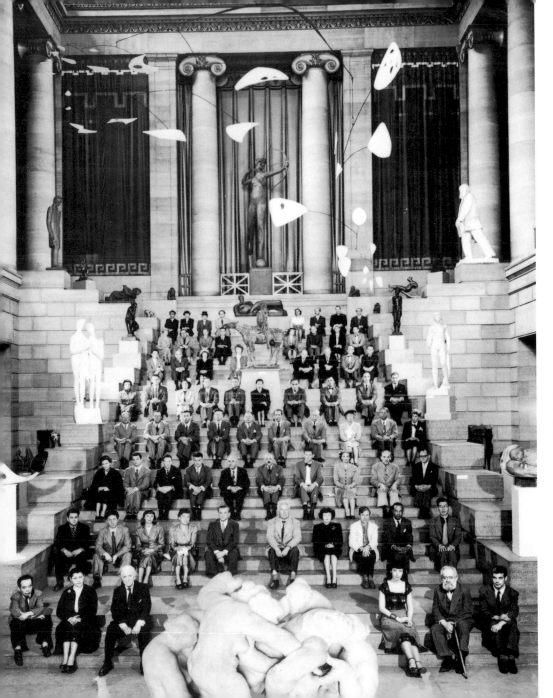

International Mobile,
1949. Calder seated
in second row, fifth
from right.

at the Venice Biennale. He won the grand prize for sculpture; some of those objects exhibited are illustrated in this volume: *Gibraltar*, *Constellation*, and *The Big Ear*.

In the summer of 1953 Calder took his family to France for a year. Stationed in Les Granettes, a hamlet in the south of France near Aix-en-Provence, he focused on painting in gouache, and at a blacksmith shop nearby he made five or six large standing mobiles conceived for the outdoors. Previously, Calder had enlarged works from small maquettes; these new works he made from designs chalked directly onto full-size steel plates, which were then cut and assembled by torch. In *Myxomatose*, the base was left rough, an immediacy that expresses the excitement Calder must have felt at being back in France—he hadn't lived there since 1937. Its title was drawn from the French term for a usually fatal disease of rabbits. These objects made in France are exceptional: Calder had never before generated such a body of work without a commission, and the objects display a certain daring that resulted from his doing so solely for his own account.

That fall, the Calders visited Jean Davidson, friend and future son-in-law, in the Loire valley. His home was in the tiny town of Saché, known as the place where Balzac would escape Paris to write. While there, Davidson and Calder agreed to a trade: three mobiles for a house, "François Premier," on Davidson's property. This seventeenth-century stone structure, built into

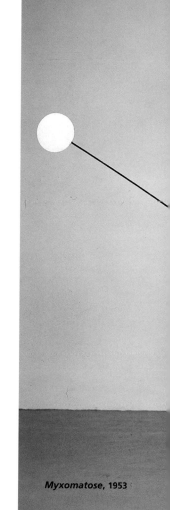

Myxomatose, 1953

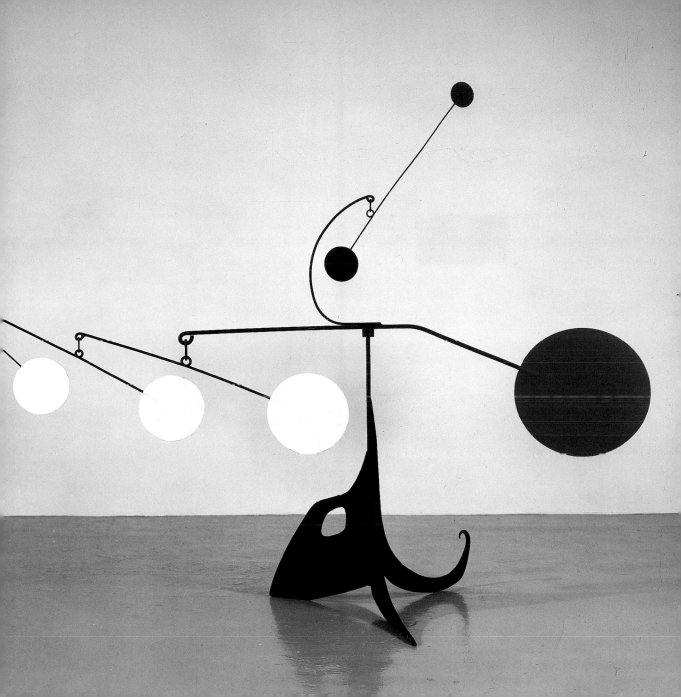

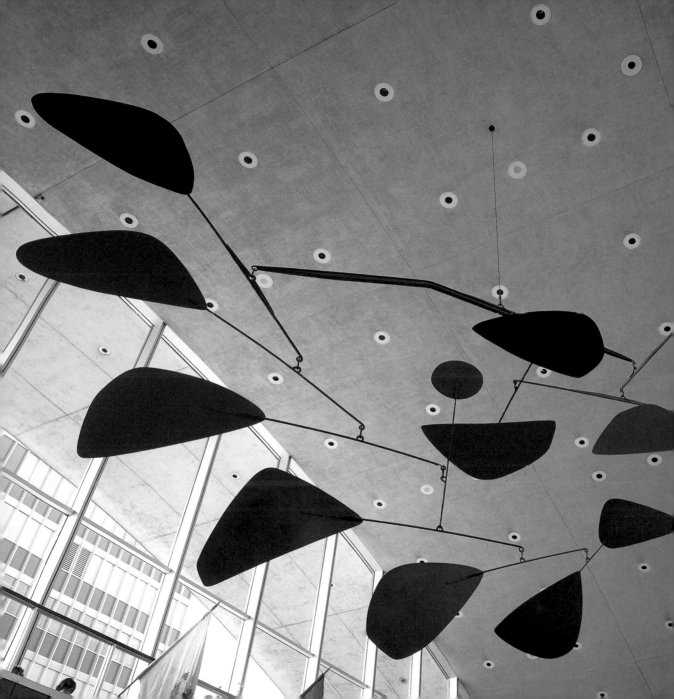

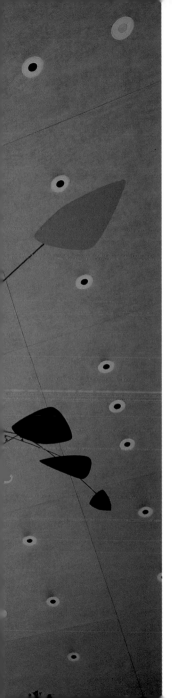

.125, 1957

the side of a cliff, was dilapidated and in severe need of repair. Calder swiftly improvised a studio in Davidson's house and constructed the sculptures. Through the winter, Davidson managed the renovation of the house, and converted the wagon shed into a studio. A second small building across the street served as the "*gouacherie*," a painting studio.

1957 was a very fulfilling year for Calder. The Port Authority of New York engaged him to make a mobile to complement the vast arc of the new international arrivals building, designed by Gordon Bunshaft of Skidmore, Owings & Merrill, at Idlewild Airport in New York. Titled .*125*, the gauge of the aluminum plates, the 45-foot-wide mobile was made at Waterbury Ironworks, Connecticut.[25] The Committee of Art Advisors at UNESCO in Paris commissioned *La spirale*, named for elements that spiral upward. The mobile top was made by Calder at Segré Ironworks, Connecticut, and the stabile bottom was made with the collaboration of Jean Prouvé after Calder arrived in France with the top.

Calder's late work is dominated by monumental scale. He continued to make objects in human scale, but his most creative energy was focused on enormous public sculpture. He was thoroughly involved in all phases of the fabrication and execution of his monumental works. At each step he would design and re-design his original composition, altering shapes, materials, balances, and colors as it suited him. He always carried a piece of

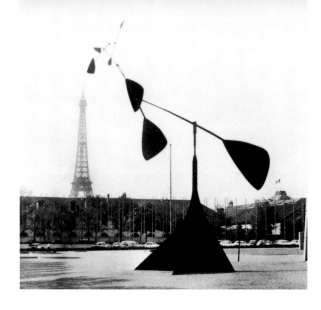

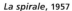
La spirale, 1957

soapstone chalk in his pocket, and when he went to work at the steel fabricators, he would pull the chalk out to mark where the ribbing and gusset supports should be welded on to give rigidity to the flat steel plates. The fabrication of his objects by techni-cians was a pure extension of himself.

Teodelapio—commissioned and supervised by Giovanni Carandente, organizer of the Spoleto Festival in 1962[26]—was made by a shipbuilding firm in Italy while Calder remained in Connecticut. Named after a local duke who wore a tricorn hat, the piece was designed to span the road and for many years the bus route ran right through the sculpture. *Southern Cross*, 1963, named for the celestial constellation that Calder had encountered during his merchant marine days, incorporates black and red,

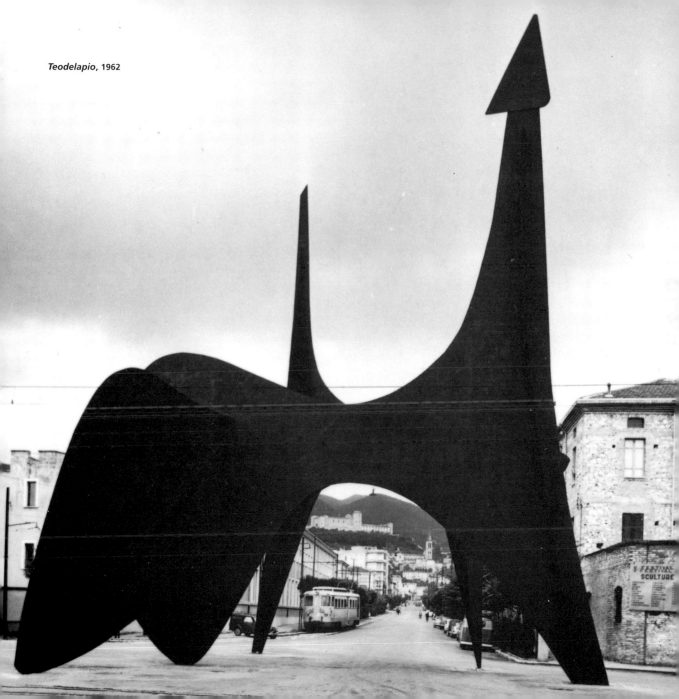

Teodelapio, 1962

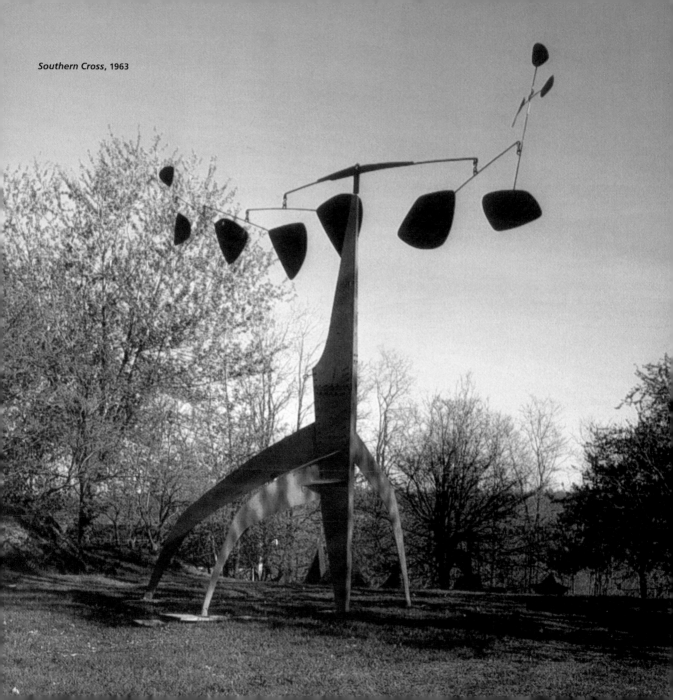

Southern Cross, 1963

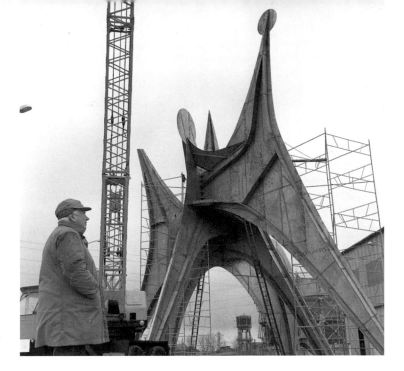

Calder at the first trial assembly of *Man*, Tours, France, 1967

Calder's two favorite colors. This elegant work was kept by Calder for his own property in Roxbury.

Man, 1967, a gigantic, unpainted, stainless steel stabile, is Calder's tallest work—standing over 65 feet high. Sponsored by the International Nickel Company of Canada, it was presented at Expo '67 in Montreal.[27] Calder had originally planned to paint the sculpture black, but he decided the unpainted surface, exposed nickel steel, would be apropos given the sponsor. For the first time Calder had intermediate maquettes fabricated for design refinements and

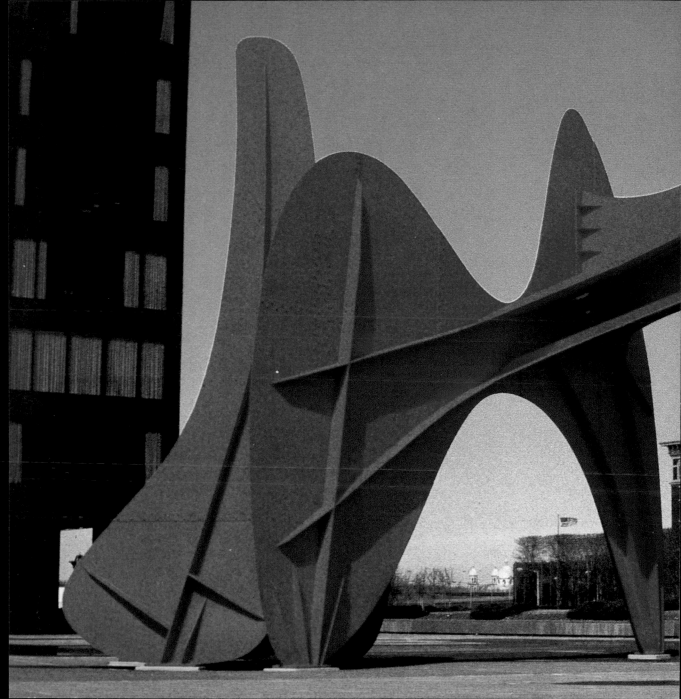

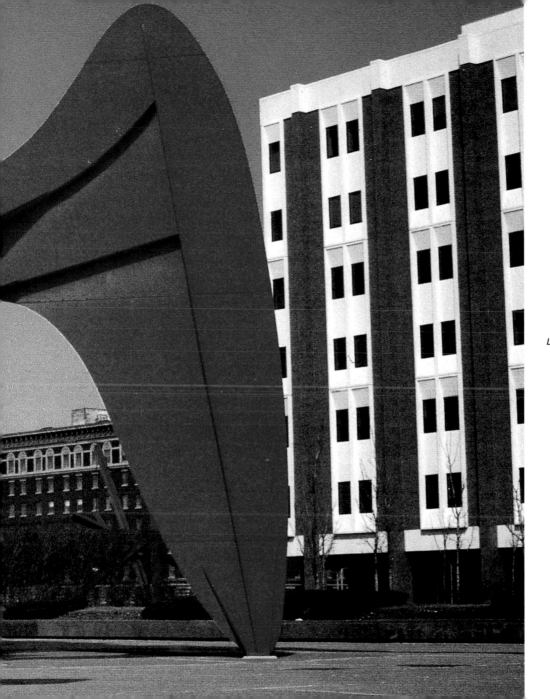

La grande vitesse, 1969

wind-tunnel testing as the work was enlarged to full-scale. The final piece is a hollow construction—the enormous plates give the illusion of thickness and relate proportionally to the sculpture's volume.

With its powerful undulating forms, *La grande vitesse*, 1969, was inspired by the name of its intended city, Grand Rapids, Michigan. It was the first public sculpture funded by the National Endowment for the Arts' public art program. Sited on a grand plaza, the piece can be viewed from above from an adjacent building. Although it might be seen as rather reserved by today's standards, the project generated a large amount of local protest. Because it was painted red, some saw the sculpture as a symbol of Communism. On the day of the sculpture's dedication, 14 June, a shot was fired at the home of Nancy Mulnix, who had been instrumental in bringing the project to fruition. Now *La grande vitesse* serves as a proud symbol of the city—a virtual icon around which an annual art festival is held.

Calder's series of crumpled-base standing mobiles culminated with *Grand Crinkly*, 1971, which truly is a grand work, having a kind of majestic presence. *Flamingo*, 1973, was commissioned by the United States General Services Administration under a new formalized program wherein .5 percent of the budget for new construction of all federal buildings went toward commissioning contemporary artists to create large public works to be incorporated into the site. Installed in front of Chicago's John C. Luczynski

Grand Crinkly, 1971, outside Calder's studio in Saché

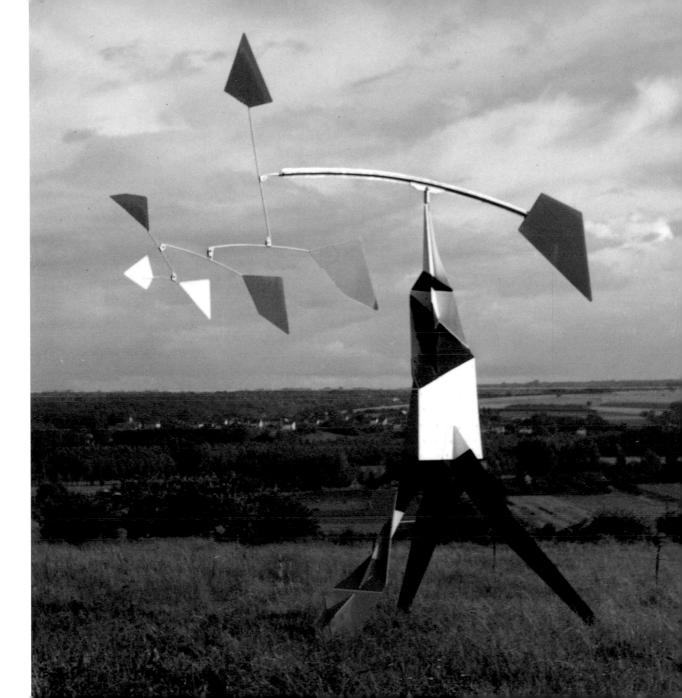

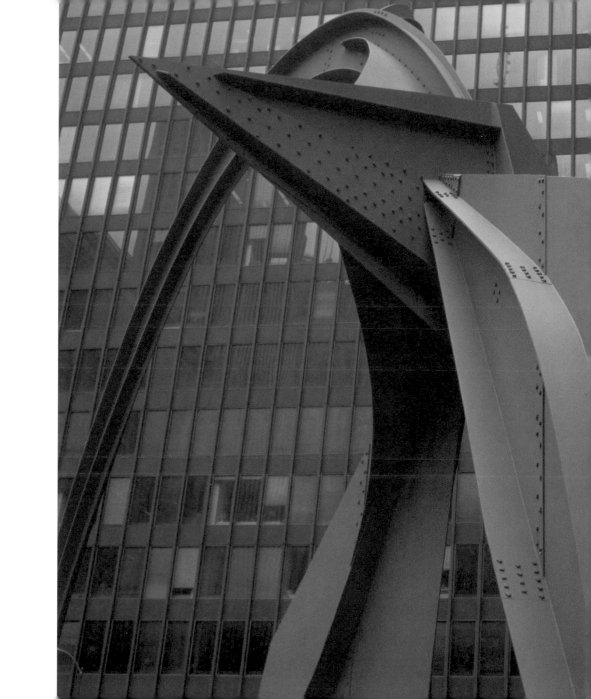

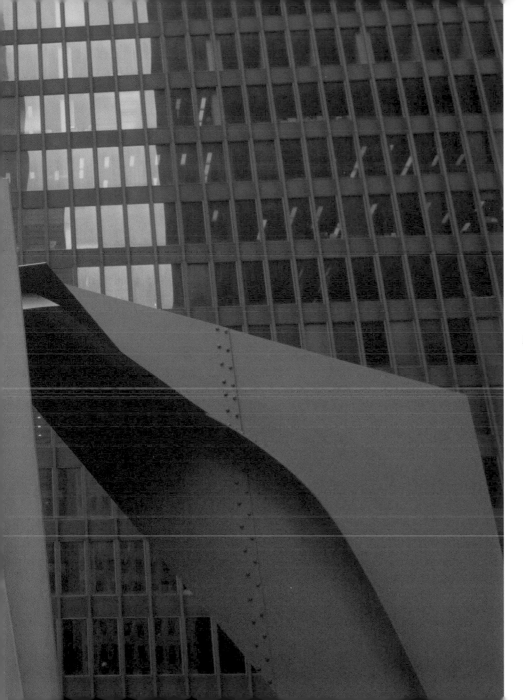

Flamingo, 1973

Federal Building, designed by Ludwig Mies van der Rohe, *Flamingo* was the very first work of art funded by this program. Its red forms play very successfully with the building, both against its sleek black structure and as reflected on its surface.

In a life spanning seventy-eight years, Calder produced over sixteen thousand works of art, including four thousand sculptures. An irrepressible experimenter, he worked consistently and deliberately throughout his career, yet his process was always intuitive. Originating new vernaculars in sculpture, he applied kinetic energy and natural forces to his inventions, and introduced an industrial solidity to art with his grand public works. •

**Calder's desk in his Roxbury
studio, c. 1964. Herb Weitman**

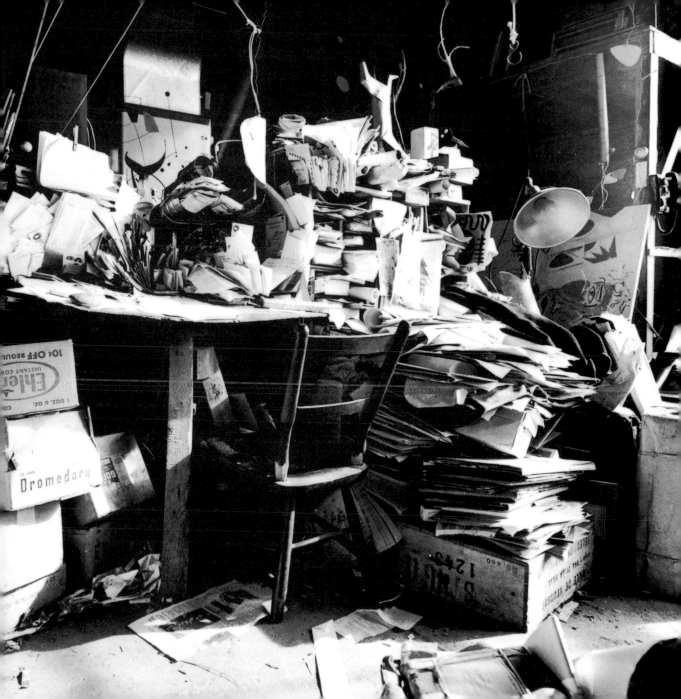

Notes

1 Archives, The Alexander and Louisa Calder Foundation, New York, Alexander Calder, unpub. MS., 1943.

2 Legrand-Chabrier, "Un petit cirque a domicile," *Candide*, no. 171 (23 June 1927), 7; Legrand-Chabrier, "Alexandre Calder et son cirque automatique," *La Volonté*, (19 May 1929).

3 Fifty-Sixth Street Galleries, New York, *Alexander Calder: Paintings, Wood Sculptures, Toys, Wire Sculptures, Jewelry, Textiles*, 2–14 December 1929.

4 Alexander Calder and Jean Davidson, *Calder, An Autobiography with Pictures* (New York: Pantheon Books, 1966), 113.

5 Galerie Percier, Paris, *Alexander Calder: Volumes-Vecteurs-Densités; Dessins-Portraits*, 27 April–9 May 1931.

6 Alexander Calder in the exhibition catalogue for *17 Mobiles by Alexander Calder*, Addison Gallery of American Art (Andover, Mass., 1943).

7 Alexander Calder in the exhibition catalogue for *Modern Painting and Sculpture*, The Berkshire Museum (Pittsfield, Mass., 1933), 2–3.

8 Galerie Vignon, Paris, *Calder: ses mobiles*, 12–20 February 1932.

9 Although today we recognize as "standing mobiles" those pieces shown in the 1931 Galerie Percier exhibition that incorporated motion with articulated elements, Arp was differentiating such sculptures from the new motorized ones.

10 Pierre Matisse Gallery, New York, *Mobiles by Alexander Calder*, 6–28 April 1934.

11 Alexander Calder, "What Abstract Art Means to Me," *Museum of Modern Art Bulletin* 18, no. 3 (Spring 1951), 8–9.

12 Archives, The Alexander and Louisa Calder Foundation, New York, Louisa Calder to Nanette Lederer Calder, 15 March 1931.

13 Pierre Matisse Gallery, New York, *Stabiles and Mobiles*, 23 February–13 March 1937.

14 Spanish Pavillion, Paris, *L'Exposition International*, 24 May–26 November 1937.

15 In 1971 Calder gave Mercury Fountain to the Fundació Joan Miró in Barcelona. Josep Lluis Sert designed this building as well.

16 Coordinating Council of French Relief Societies, Whitelaw Reid Mansion, New York, *First Papers of Surrealism*, 14 October–7 November 1942.

17 Archives, The Alexander and Louisa Calder Foundation, New York, Alexander Calder, unpub. MS., 1943.

18 Pierre Matisse Gallery, New York, *Calder: Constellationes*, 15 May–15 June 1943.

19 H. Harvard Arnason and Ugo Mulas, *Calder*, (New York: Viking Press, 1971), 202.

20 It has often been written that Calder's constellations of 1943 had been inspired by Joan Miró's series of small-scale paintings on paper also called constellations (though not named such until a decade later). Calder did not see these works of Miró until they were first exhibited in New York at Pierre Matisse Gallery in 1945.

21 The Museum of Modern Art, New York, *Alexander Calder: Sculptures and Constructions*, 29 September–28 November 1943 (extended to 16 January 1944). Calder's first retrospective exhibition, *Calder Mobiles*, was held at the George Walter Vincent Smith Gallery in Springfield, Massachusetts, 8–27 November 1938.

22 Galerie Louis Carré, Paris, *Alexander Calder: Mobiles, Stabiles, Constellations*, 25 October–16 November 1946.

23 Maximum package dimensions were eighteen inches (length) and twenty-four inches (circumference) (Calder 1966, 188).

24 Philadelphia Museum of Art in collaboration with the Fairmount Park Art Association, *3rd International Exhibition of Sculpture*, 15 May–11 September 1949.

25 After installing the mobile in the terminal, Calder referred to it as *Flight*, a prosaic sobriquet derived from its location. Idlewild International Airport also underwent a name change and is now known as Kennedy International Airport.

26 Fifth Festival of Two Worlds, Spoleto, Italy, *Sculptures in the City*, 21 June–22 July 1962. Curated by Giovanni Carandente.

27 Montreal, Canada, *Expo 67*, 28 April–27 October 1967. *Man* is installed on Ile Sainte-Hélène.

Index of Works of Art
References are to page numbers

23 *Croisière*, 1931
Wire, wood, and paint
37 x 23 x 23 in.
Private collection, New York
Photograph © 1997 A.S.C. Rower

24 *Feathers*, 1931
Wire, wood, lead, and paint
38½ x 32 x 16 in.
Private collection
Photograph © 1997 A.S.C. Rower

25 *Object with Red Ball*, 1931
Wood, metal sheet, wire, and paint
61¼ x 38½ x 12¼ in.
Private collection
Photograph Stalsworth/Blanc

26 *Untitled*, 1931
Wood, wire, paint, and motor
Approximately 36 x 36 x 12 in.
Photograph Marc Vaux
Courtesy The Alexander and Louisa
Calder Foundation, New York

27 *Cône d'ébène*, 1933
Ebony, wire, and metal bar
106 x 55 x 24 in.
Private collection, New York
Photograph Stalsworth/Blanc

28 *Gibraltar*, 1936
Lignum vitae, walnut, wood,
wire, and paint
51⅞ x 24¼ x 11⅜ in.
The Museum of Modern Art, New
York, Gift of the artist, 1966
Photograph © 1997 The Museum of
Modern Art, New York

29 *Object with Red Discs*, 1932
Metal sheet, iron ball, wire,
and paint
88½ x 33 x 47½ in.
Whitney Museum of American Art,
New York
Photograph © 1997 Whitney
Museum of American Art

30 Calder with *Black Frame*, 1934
Wood, metal sheet, wire, paint,
and motor
37 x 37 x 24 in.
Private collection, New York
Courtesy The Alexander and Louisa
Calder Foundation, New York

30 *A Universe*, 1934
Iron pipe, wire, wood, string, paint,
and motor
40½ x 31 x 29 in.
The Museum of Modern Art, New
York, Gift of Abby Aldrich
Rockefeller (by exchange), 1934
Photograph © 1997 The Museum of
Modern Art, New York

31 *The Orange Panel*, 1936
Plywood, metal sheet, wire, paint,
and motor
36 x 48 x 9 in.
Private collection

33 *Red Panel*, 1936
Plywood, metal sheet, copper
tubing, wire, string, and paint
108 x 60 x 45 in.
Private collection
Photograph Stalsworth/Blanc

34 *Snake and the Cross*, 1936
Metal sheet, wire, wood, and paint
81 x 51 x 44 in.
Private collection, New York
Photograph Robert Grove

35 *White Panel*, 1936
Plywood, metal sheet, wire, string,
and paint
84½ x 47 x 51 in.
Private collection
Photograph Stalsworth/Blanc

37 *Untitled*, 1934
Metal sheet, wire, brass, lead,
and paint
113 x 68 x 53 in.
Private collection
Photograph Stalsworth/Blanc

38 *Steel Fish*, 1934
Metal sheet, rod, wire, lead, and paint
115 x 137 x 120 in.
Private collection
Photograph © 1997 A.S.C. Rower

39 *Whale*, 1937
Metal sheet, bolts, and paint
68 x 64 x 47 in.
Private collection
Photograph David Heald, New York

40 Calder with *Mercury Fountain*, 1937
Metal sheet, rod, wire, mercury,
paint, pitch, and pump
44⅞ x 115½ x 77⅜ in.
Fundació Joan Miró, Barcelona
Photograph Hugo P. Herdeg
Courtesy The Alexander and Louisa
Calder Foundation, New York

41 *Untitled*, 1941
Metal sheet, wire, and paint
117 x 45 in.
Private collection
Photograph Stalsworth/Blanc

42 *Lobster Trap and Fish Tail*, 1939
Metal sheet, wire, and paint
102 x 114 in.
The Museum of Modern Art,
New York, Gift of the Advisory
Committee, 1939
Photograph © 1997 The Museum
of Modern Art, New York

42 *Un effet du japonais*, 1940
Metal sheet, wire, and paint
80 x 80 x 48 in.
Private collection
Photograph © 1997 A.S.C. Rower

43 *The Spider*, 1940
Metal sheet, rod, and paint
95 x 99 x 73 in.
The Patsy R. and Raymond D.
Nasher Collection